Weegee

Weegee

Introduction by André Laude

Thames and Hudson

On the cover: A Gun Shop Sign, 1943

First published in Great Britain in 1989 by
Thames and Hudson Ltd, London
Originally published in France by Centre National de la Photographie
Copyright © 1985 by Centre National de la Photographie
English translation copyright © 1986 by Centre National de la Photographie

Printed and bound in Italy

£4·95

St.Bk.

PO 24797

980136

"PRIVATE" EYE

Photography, it is said, is writing with light. Arthur Fellig, alias Weegee, son of a rabbi (the detail is not unimportant), works with a knife, a scalpel, the flash at night. Out of the shadows, he snatches careworn faces, sorrowful and grotesque, with their outrageous, often painted features.

"There were so many dead gangsters stretched out in various localities every night that the editors were getting real choosey. 'After all', they said, 'this is a family newspaper!' I was taking some of the best killing pictures of my career. Sometimes I even used Rembrandt side lighting, not letting too much blood show. And I made the stiff look real cozy, as if he were taking a short nap. But the market was flooded. I had so many unsold murder pictures lying around my room that I felt as if I were renting out a wing of the City Morgue."

No one of Weegee's photos can really be classified as a scoop. In reality, Weegee practices a mysterious alchemy. He transmutes into an autonomous reality, into *jamais-vu*, the offerings of everyday reality caught by his piercing, razor-sharp look. He is not ignorant of the fact that the world of appearances is deceptive. His reporter's 'coldness' is a carnival mask. The scoundrels, the derelicts, the trembling phantoms torn apart by the neon lights of city life, all these broken people that he photographs are, in the final analysis, actors in a drama that has its roots in antiquity and which surpasses by far any mere anecdote. I see in them something like a somber, tormented, metaphysical statement of the fixed image. Weegee acts out his internal theater in the nighttime streets of New York with the spontaneous complicity of others unknown, anonymous people, hoodlums, misfits.

*"When criminals tried to cover their faces it was a chal-
lenge to me. I literally uncovered not only their faces, but their
black souls as well...*

*"I don't mind photographing gangsters littering up the
gutters. To me, it's in the nature of a slum clearance project and
I say, 'Good riddance!' But there are some events that almost
break my heart to photograph, especially family tragedies."*

Everything is a photo, from the glibness of the street
hawkers under the el at Barbès Rochechouart in Paris, to the
silence of the mystic seer in Mecca. Everything is a photo,
including the scum of the earth, its rottenness and its dirt;
including the most disgusting, gruesome, and atrocious ele-
ments here below. "Crime is my oyster, and I like it," Weegee
would say. That particular oyster was full of black pearls.

Crimes of passion were not Weegee's only "oyster." Of
course, he did have a soft spot for corpses lined up along the
asphalt, from the Bronx to the Bowery, from uptown Manhat-
tan to the Lower East Side, the corpses of Mafia hitmen,
Sicilians dealing in "horse," and in women. Yes, he was fond of
the "stiffs," of miserable criminals trying to play life or death,
like Humphrey Bogart in *To Have and Have Not*. There were
also the fires, the overnight shelters, the bank holdups, the car
accidents, and the arrests made by burly cops loaded down
with guns. There were the faces of women in badly lit, squalid
bars and female impersonators, a host of losers floundering
around in the shadow of the Statue of Liberty with one or two
cents in a pocket with a hole in it. The faces are eroded by
alcohol, ravaged by bad luck, by wretchedness, by the
unshakable unhappiness that clings to the skin like fog on a
river.

Weegee was always fascinated by the underdog. With
his Speed Graphic 4" x 5" in hand, he plunged over and over
again into this vivarium of shit, blood, bruises, and open
wounds; of flesh charred by fire, eaten up by gambling,
riddled with holes from the bullets of killers directly descen-
ded from Billy the Kid, arrogant, cruel, solitary, and childish-
ly innocent; of brains no bigger than the slugs spewed out by
the revolvers of Eliott Ness and his band of lawmen. This was
Baby Face Nelson country.

*"I started to freelance out of Manhattan police headquar-
ters. Having had a few occasions to go there while I was with
Acme, I figured that this would be the logical place to make my*

headquarters. Here was the nerve center of the city I knew, and here I would find the pictures I wanted.

"I would arrive at midnight. The cop at the information desk would be dozing, a farm journal in his lap, dreaming of the day when he could turn in his papers, retire to a Florida farm, and raise chickens. The police teletype machine would be singing a song of crime and violence: Body floating in East River, DOA (dead on arrival... New-born baby found alive in ash can... Man at emergency ward at Bellevue Hospital with his pecker stuck in bottle (Hi, Doctor Kinsey!). This was to be my world for the next ten years, my private island, my little niche. Crime was my oyster, and I liked it."

Long live free America! The land of asylum, the land of asylums, gold mines and hell, paradise regained, through the Bible or the Torah, and Lucifer's garden.

Thousands of reporter-photographers have done and continue to do what Weegee did, swamping the news with pictures that sicken the heart and rattle the conscience - at least when there is a conscience. Their names have passed into oblivion. No one would dream of mentioning them in a history of photography between a Diane Arbus and a Manuel Alvarez Bravo. But Weegee, Weegee was unique, and cards (marked, of course) on the table, he was an authentic, a great, a genius of a photographer. he transcended the daily spectacle of horror, of ugliness and of violence. Undoubtedly, he had a good eye for a picture, but there was also the intrinsic quality of the man, of his profound quest, of his anguish, and his confrontation with a Protean, complex, and febrile America, where the unscrupulous gangster rubs shoulders with the impassioned preacher, the whore with painted nails, the nefarious banker, and the dreamy idealist.

"From midnight to one o'clock, I listened to calls to the station houses about peeping Toms on the rooftops and fire escapes of nurses' dormitories. The cops laughed those off... let the boys have their fun. From one to two o'clock, stick-ups of the still-open delicatessens... the cops were definitely interested in those. From two to three, auto accidents and fires... routine coverage that the cops had learned how to handle when they were still rookies at the Police Adademy. At four o'clock, things became livelier. At that hour the bars closed, and the boys were mellowed by drinks. The bartender would holler 'Closing up!' But the customers would refuse to leave – why go home to their

nagging wives? The boys in blue would escort them out, then jump in for a few quick drinks themselves in the darkened back rooms. Then, from four to five, came the calls on burglaries and the smashing of store windows.

"After five came the most tragic hours of all. People would have been up all night worrying about health, money, and love problems. They would be at their lowest physical and mental state and, finally, take a dive out of the window. I never photographed a dive... I would drive by. Nature was kind. A woman would land on the sidewalk, one shoe off, but with never a mark on her face. The cops would cover her body with newspapers. I couldn't take it; I was finished for the night."

Before the photographer came the individual. It may be worthwhile to recall that Weegee was of Austro-Hungarian origin and, as already mentioned, the son of a rabbi. In other words, he is one of the sons of that empire which - only a few years after the family emigrated to New York - foundered, body and soul, with the First World War. An Atlantis engulfed by blows from the butts of guns, diplomats hacking up the map of Europe, breaking up frontiers to create others. Nations constructed in the past sinking into oblivion, others pieced together in between drinking bouts and sickly from the start.

Weegee came from a sensitive and cultivated world which shone at its brightest in Vienna during the last few decades of the nineteenth century, up to the eve of the great butchery. Franz Kafka, Robert Musil, Oscar Kokoschka, Gustav Mahler, Alban Berg, Anton Webern, Gustav Klimt, Hugo von Hofmannsthal. Not to mention a certain psycho named Adolf Hitler, already hovering on the edge of madness. You can't be Austro-Hungarian and the son of a rabbi and expect it to mean nothing when you are born with the new century.

To be twenty years old in 1920 was terrible for anyone who was not an imbecile. First and foremost was the stench of corpses from the First World War, an inexpungible pestilence in the air. Already the shadow of Auschwitz was lengthening. Everywhere, riots and proletarian insurrections were grist for the ruthless mills of history, which, as everyone knows, is written only by the strongest: Russia, already under Stalin's thumb; America. In a devastated Europe, the bourgeois class struggled along, gasping, hauling around suitcases filled with worthless bank notes.

Dada – the movement that preceded and foreshadowed surrealism along with Ubu, Jarry's brilliant character, realize the program of history: disorder. Everything is ditched. Even love is infected. Fritz Lang's *M.* and Georg Pabst's *Lulu* wander about the ruins of a vast territory peopled with white shadows, flesh, and souls devastated by one of the most terrifying cataclysms ever experienced.

Even if he was only seven when he became an exile, I am convinced that, beyond all appearances, Weegee's true personality was profoundly linked to these realities. He lived through them firsthand, or absorbed them through reading, through films, paintings, and cabaret songs with titles like "The Eleven Hangmen" or "Noise and Smoke."

There is definitely such a thing as a singular Austro-Hungarian sensitivity. It is all the more singular when it is tangled up with a Jewish background, a unique knowledge of darkness and gloom, an art of approaching the *backside of things,* of *crossing through the looking glass;* when it is associated with a faculty for resurrecting death out of each particle of life and for establishing a special relationship with the *realm of putridness ;* when there is an obsession with *rigor mortis,* a grasp of the agony of being.

"I was born in Austria, and came to America when I was ten years old.

"As hundreds of other men before him had done, my father had left for America first to earn enough money to bring over the rest of the family. He had settled on the Lower East Side, where most of the immigrants had flocked, largely because their relatives and friends were already settled there. He struggled in one job after another, desperately trying to save up the passage money to pay our way...

"At Ellis Island, which seemed the most beautiful place in the world, the immigration health officers examined us closely. They especially checked our eyes. One kind man gave me a banana and an orange. I had never seen a banana or an orange in Zlothev. The man carefully peeled the banana for me. I did the eating myself. It tasted good... like what, I don't know, but good. I figured that if a banana was to be peeled, so was an orange, and peeled that myself. The orange, too, tasted good.

"Father was waiting to meet us. He showed the authorities enough money to convince them that we would not become public charges –. I think it was twenty dollars – and then took

us to our first home in New York, a rear tenement house on Pitt Street near Rivington.

"The two rooms over a bakery were as hot as a furnace in hell. The rent was twelve dollars a month, but in those days who had that kind of money?"

These people, coming from "elsewhere," knew perfectly well that the villain snatches the good and vice-versa, that vice can lead to glory and prestige. They knew that virtue is a heavy lid, under which a thousand creatures – rats, lice, bedbugs, spiders – swarm and mill about. They knew that the most racked and ruined body can tenderly enclose the spirit of a heavenly cherub. They knew that the day's accursed bread is the ransom for the conquest of lucidity, of the necessary and vital disillusion.

I do not wish to suggest that Weegee spent all his childhood beating his head against the wall or shivering in fright and terror. I am simply saying, but with wholehearted certainty, that he grew into adulthood with the star of Disaster encrusted in his skin. Somewhere he is, therefore, a "survivor."

Second chapter: the American exile. A dual movement: stranger in a world henceforth buried under the chronicles of historians, journalists and, specialists, and stranger, somewhere, in the New World, despite all it has that is fascinating and disturbing.

America: no salvation for losers Indians, blacks, Jews, all angrily harnessed to the wobbly cart of daily survival, abetted by prayer, daydreams, alcohol, music, and madness. Madness: exit! America: a white-hot cauldron, where all the dazzling victories, all the irremediable iniquities East of Eden are possible. And so the harder they fall! Bread, whiskey, sleep, love with a street tramp – these are the labors of Hercules; these are daily feats.

"I tried my best to do like Horatio Alger, who as a newsboy went from rags to riches. But I soon came to the conclusion that Horatio must have been a phony. No one could have been so pure in heart. So I stopped reading about Horatio Alger and turned to Nick Carter. The famous detective became my new hero, and, after a week as a newsboy, I switched to selling candy. I went to the wholesale confectioners where the candy stores bought their supplies and asked for a couple of dollars of candy on credit...

"Thereafter, I made a profit of one to two dollars a day selling candy. I would start off making the rounds of the rag sweatshops right after school. Lucky for me, the girls, who made only five dollars a week themselves, always seemed to have a penny for a chocolate bar or a stick of chewing gum... at least, they were willing to buy from me. Sometimes I gave the girls candy on credit. At the end of the week they always paid up, and I could settle with the wholesalers. I made 100 percent profit... when I didn't eat too much of the candy myself."

"Often I was chased by the special cops of the subways because the candy stands up on the platforms considered me unfair competition. But I always came back. I stayed on until I had sold out my stock, at about eight o'clock at night, and then proudly went home to hand over my money, in pennies and nickels, to my mother.

"My earnings, small as they were, helped to keep the family in food and in secondhand clothes, for, except for the free rent, my father was doing poorly as a wage earner...

"Our rooms were freezing cold in the winter and roasting hot in the summer. To get away from the heat, we kids used to sleep on the fire escape. That was all right until it began to rain. Then back we had to go to the sweltering rooms. Waiting for us were the bedbugs. They had the last laugh and bite."

America: jazz, Harlem, prohibition, Al Capone, Scarface, the Mafia, Lucky Luciano. Urban America: cops, trash, dilapidated buildings, bashed-in doors, broken windows, beautiful children with snotty noses, dealers and addicts stumbling along the sidewalks, seedy vagrants hunting for a penny to wind up the night, loonies of all kinds, colors, and creeds. *Beyond this point your ticket is no longer valid.* People without a country, illegal immigrants without papers, shipwrecked there beyond the last vacant lot. Children from Bohemia and Moravia, from Lodz and Palermo, from the rue des Rosiers and from Lonely Street. New York: skyscrapers, a blazing furnace, a bustle celebrated by the Homer of the New World, Walt Whitman. New York: a gigantic mass of muscles, a garbage dump, neon nights, nothing days, an incredible electric energy, stress and strass at every street corner, hoodlums, hookers, hoodoo, welfare merchants, dream merchants – *Time is money,* and the answering echo, *Money is time.* Money, power, sex, decay.

Weegee knew that Holy Trinity – power, ass, money – is

the law. He did not photograph fairy tales but facts summer facts, winter facts, just the facts, ma'am.

See Weegee run, see him run all around the city, there where crime flourishes, there where the flowers of depravity bloom. Let the others, the luckier ones, the posher ones, pursue the pictorials, with a wink at Sisley, Renoir, and Picasso concocting unsuccessful mixtures of genres. Let the others labor in their more or less well equipped darkrooms. Weegee is an outdoor photographer, going where the wind blows. He goes where it reeks of addicts shooting up, of bootleg alcohol, of the sweat of the wives of losers who strut around to convince themselves that they are more than shit.

"No racketeer on the FBI's list of the top ten public enemies made the grade until he had been photographed by Weegee. I was finally honored for my contributions by being called (by the boys) the official photographer for Murder, Inc.

"I took a leaf out of the racketeers' book and took over New York City for myself. No other free-lance photographer was allowed to work out of Manhattan police headquarters... this was my exclusive territory. One guy tried to muscle in, but the cops wouldn't let him get near the teletype machine, and the reporters chased him out of the press building. I exiled him to Brooklyn, where the only thing that happens is an occasional lumberyard fire."

You either know it or you don't (the legend!). Weegee had fixed up the radio in his car so he could pick up the cops' and the firemen's calls. For him, night was the time to go out hunting. Hunting for scoops. Murder in Manhattan: three dead. Rape in Bronx bar. Transvestite stabbed on 42nd Street. Weegee would jump up, excited, his heavy camera within arm's reach, a big cigar dangling from his mouth, his stomach lurching from the last gin downed at Bloody Mary's, an old friend's place. Leaping out of his car like a bat out of hell, jostling the cops around, framing the shot. *Click!* He, also fixed up the trunk of his car so it was like a traveling darkroom. In the next day's papers (the Post, the Sun, the Telegram, the News, the Mirror) a corner of the veil of the previous turbulent night would be lifted. And Weegee could go grab a few hours' sleep, keeping his eyes and ears open, just in case.

"I bought myself a shiny new 1938 maroon Chevy coupe. Then I got my press card and a special permit from the big brass to have a police radio in my car, the same as in police cars. I was the only press photographer who had one."

"My car became my home. It was a two-seater, with a special extra-large luggage compartment. I kept everything there, an extra camera, cases of flashbulbs, extra loaded holders, a typewriter, fireman's boots, boxes of cigars, salami, infrared film for shooting in the dark, uniforms, disguises, a change of underwear, and extra shoes and socks".

"I was no longer glued to the teletype machine at police headquarters. I had my wings. I no longer had to wait for crime to come to me; I could go after it. The police radio was my life line. My camera... my life and my love... was my Aladdin's lamp."

"I would start my tour at midnight. First, I checked the police teletype for background on what had been happening. Then, in my car, I would turn on the police radio, then the car radio, which I tuned to the egghead stations for classical music. Life was like a timetable, tragic but on schedule, with little bits of comedy relief interspersed among the crimes."

Weegee invented or reinvented, superbly, an esthetic of speed, and an esthetic of black and white. With Weegee, one of my most intense convictions about photography is borne out: black and white reveals it; color attacks and masks it. The best angle has to be found right away. I'm thinking of a picture Weegee took, one that I don't have here in front of me. It's of several women who look Sicilian, they are wringing their hands, tearing at their faces, their eyes bulging with grief. What could have happened here? What is happening is that the families of these women are trapped in the ferocious fire raging in the house across the street and are burning to death. Weegee deliberately leaves the burning building out of the picture. He frames only these three or four figures of desolation. He forces us to decipher the spectacle of human suffering. He may be getting a scoop, but in absolute terms, he is doing something else. He is providing an indelible image of faces ravaged by the intolerable. He's not trying to hit below the belt. He's just saying, "That's life too".

"Another night, when I had gotten an early start, a call came in over the police radio about a two-alarm fire in the

Puerto Rican section. I got there quick. The electrical generator was pounding like a human heart, breathing life into the searchlights and energy into the high-pressure hose trucks. People were counting noses and embracing their families and neighbors, who had gotten out. I stayed close to the chief. His aide came out and said, 'It's a roast,' meaning that someone had been burned to death. A mother with a shawl around her was clinging to one of her daughters and looking up at the building. The fire was over. Another daughter and a younger child, a baby, had been burned to ashes. Overwhelmed by the tragedy, they were looking toward the building, their hope about gone. I cried when I took that picture..."

"I was through for the night. Those lousy fire-trap tenements ! The image of the two crying women was to haunt me the rest of my life. I was raised in a tenement, and I just couldn't escape them. The Fire Department used my picture in their Fire-Prevention Week campaign. A lot of good it did for the young mother and the baby that had been burned to death ! It couldn't bring them back to life."

You catch yourself thinking that Weegee was perhaps a wildcat Zen Buddhist. He doesn't miss the mark – he goes right through it. The arrow continues its flight straight to the heart of the land of truth. He lays bare the things about which, in general, we remain mute, voiceless, embarrassed. Speak to me of love ! It's less risky at the dinner parties that delight the ladies whose sparkling jewels adorn skin already beginning to sag and whose unreality Weegee captures – not cruelly, because he doesn't know cruelty. Yes, I just said cruelty. Enough has been said of Weegee the sadist, the neurotic, the nocturnal prowler, tirelessly hunting out corpses, sexual turpitudes, human waste. Weegee respects the "other." He is of the same cut as phtographers like Walker Evans, Dorothea Lange, Ben Shahn, Arthur Rothstein, and others, who worked with the same respect and the same passion to reveal truth while photographing America's rural poor, between 1935 and 1942, for the Farm Security Administration, part of Roosevelt's New Deal government. Weegee loves the human race precisely because of its weakness, its limitations, and its crimes. Far from any idealistic, mind-dulling belief, he knows that within the majority of beings – aside from a few truly lost cases – there exists a glimmer of light, the capacity to say the word that saves and absolves, to make the gesture

that uncovers, behind the basest of criminals, a human adventure that was detoured, deviated, led astray. Weegee's pity makes me think of Céline, the Céline who, if you can forget the ignoble writings devoted to the bloody denunciation and condemnation of the Jewish people, wrote *Voyage au bout de la nuit,* a satire of humanity.

Weegee's art – because it is art – resides in that grasping of the truth, captured in the immediate reality and glimpsed in the most dramatic manner. Weegee was there to see the amazing expansion of the written press, television and the networks not yet having established their powerful reign. The use of pictures also expanded, to satisfy a world more and more curious to see images not only of local items but of international news – which became increasingly hot beginning in the thirties.

Weegee's anti-intellectualism is a sort of travesty of his true, profound art. It means that Weegee is biologically 'hooked' on the immediate, in preference to any preconceived construction of a traditionally artistic type. He never theorized about what he saw and photographed. He makes us see, and that is important. In this sense, his "thriller realism" is just as important as the surrealism of Man Ray or Alvarez Bravo. He makes us use our imagination and sends us back to our fantasies, to the myths hidden under the veneer of "proper" civilizations.

Naked city! Naked life! Naked death!

André Laude

Translated by Marianne Tinnell Faure
Quotations excerpted from
Weegee by Weegee: An Autobiography
(New York: Da Capo Press, 1961)

1. In the street.

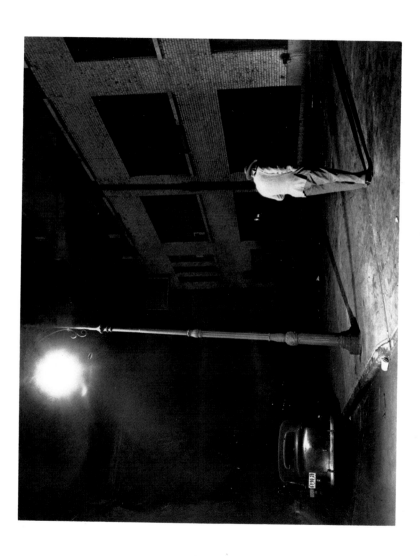

2. Untitled.

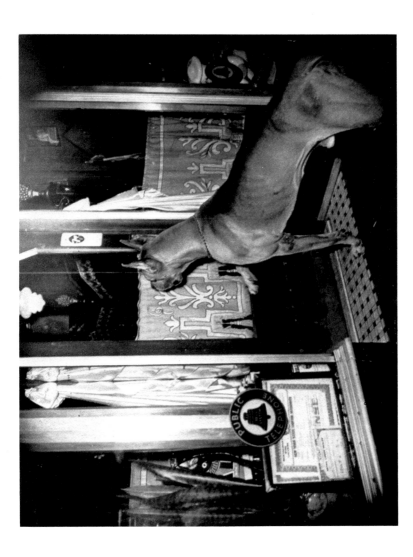

3. Night shelter in the Bowery, ca. 1938.

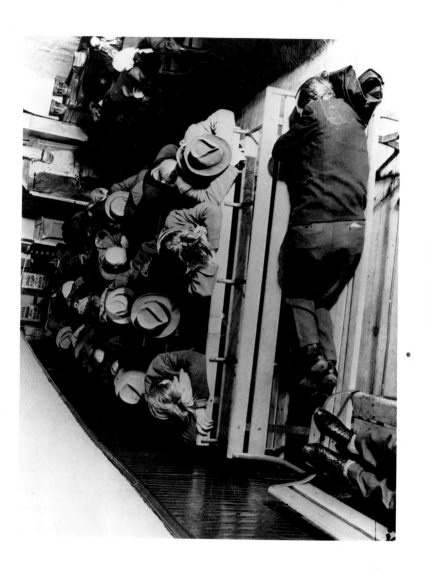

4. Dead man in a street.

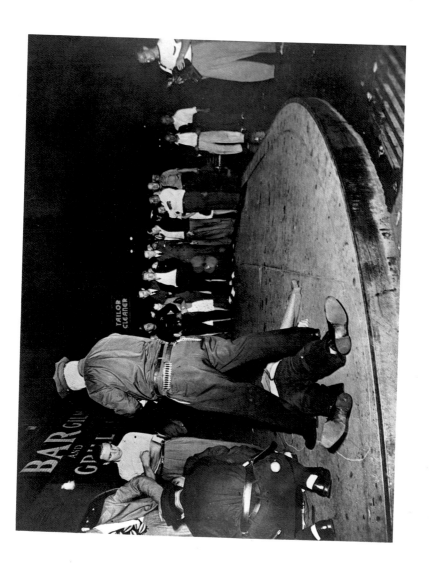

5. Rescue, ca. 1938.

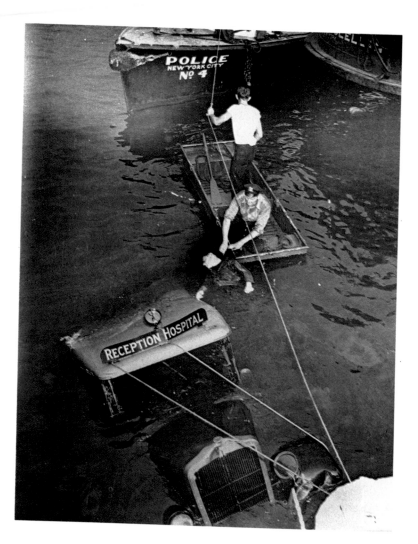

6. Her wounded husband is arrested for killing a relative, 1938.

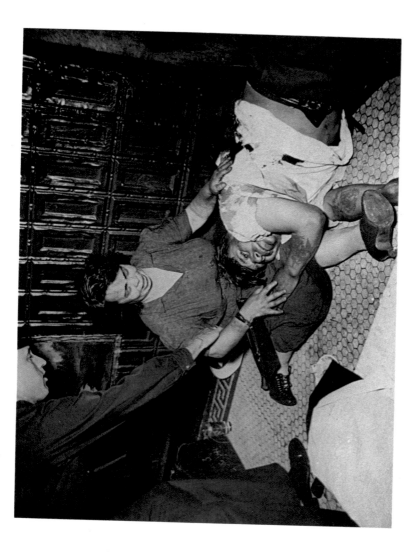

7. A winter's night fire, 1947.

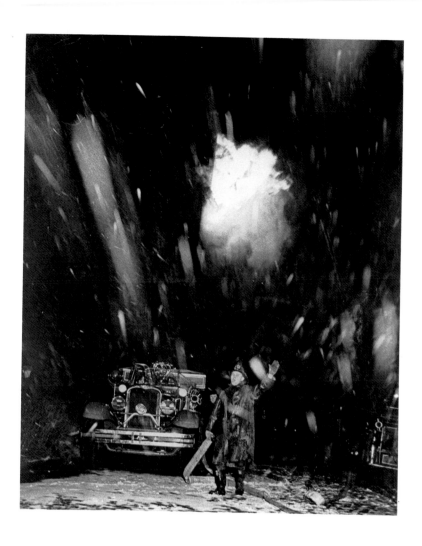

8. Fire in Harlem - her kids are still in the burning building, 1942.

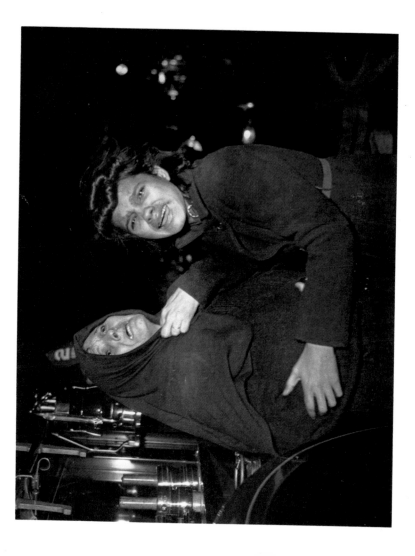

9. Murder victim.

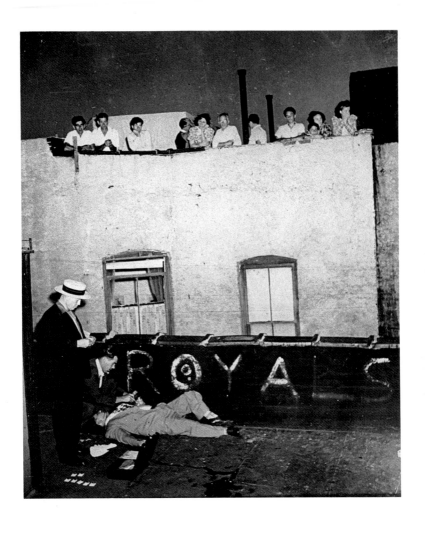

10. On the fire escape, ca. 1940.

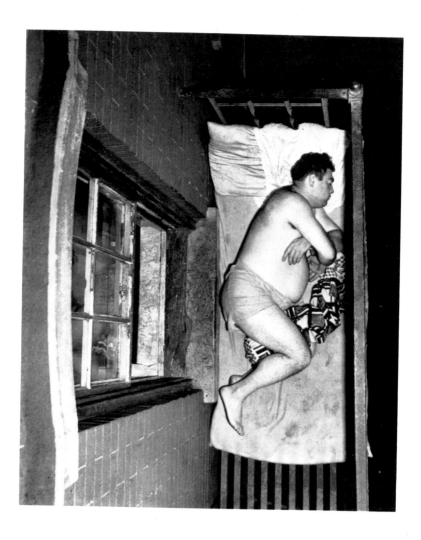

11. Hedda Hopper.

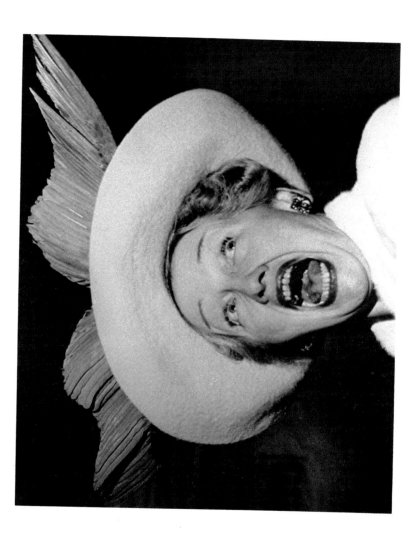

12. Women in a restaurant, 1943.

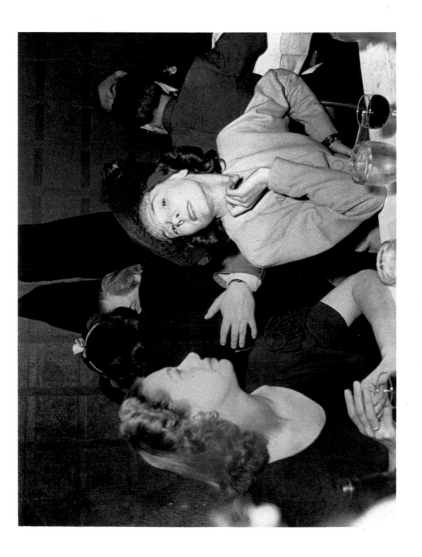

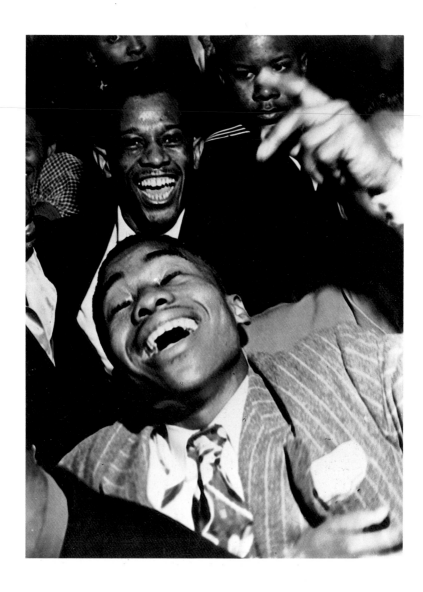

13. At a jazz club in Harlem.

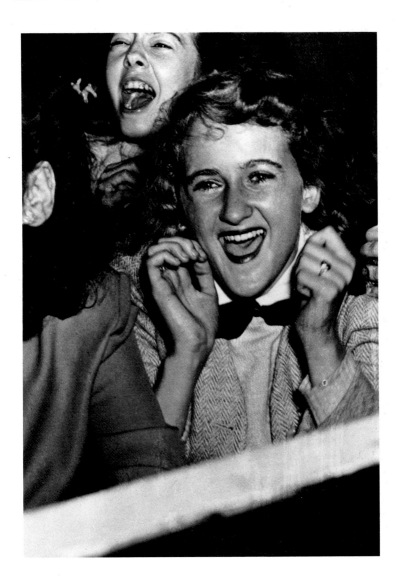

14. Listening to Frank Sinatra, Palace Theatre, 1944.

15. Easter Sunday in Harlem, 1940.

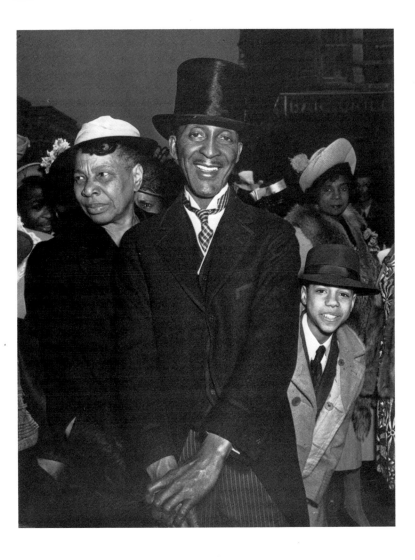

16. At Sammy's in the Bowery, 1943.

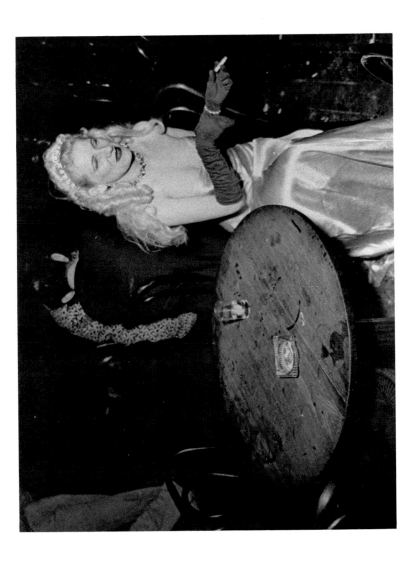

17. New Year's Eve at Sammy's in the Bowery, 1947.

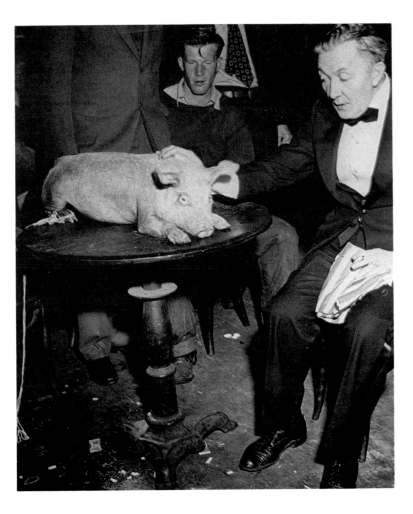

18. At Sammy's in the Bowery.

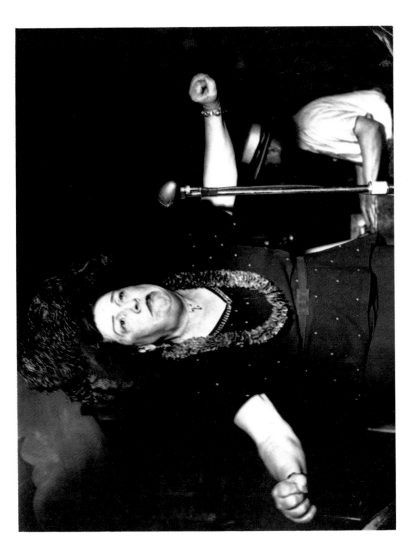

19. Children's performance, ca. 1940.

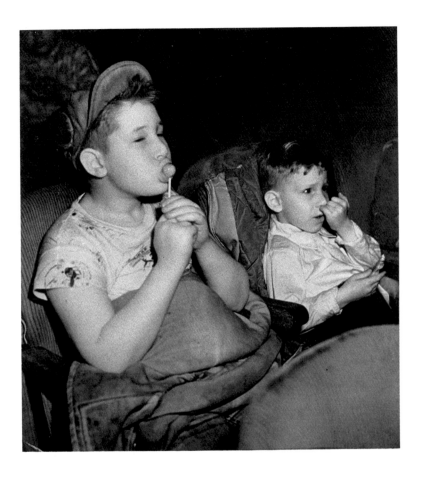

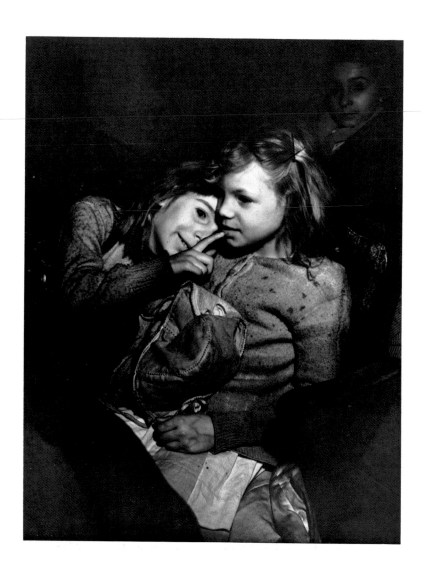

20. 21. Children's performance, ca. 1940.

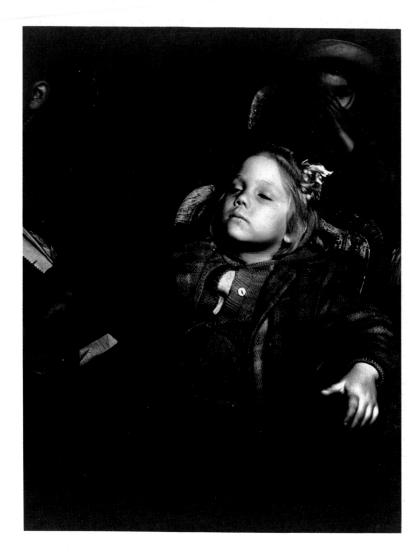

22. Lovers at the movies, ca. 1940.

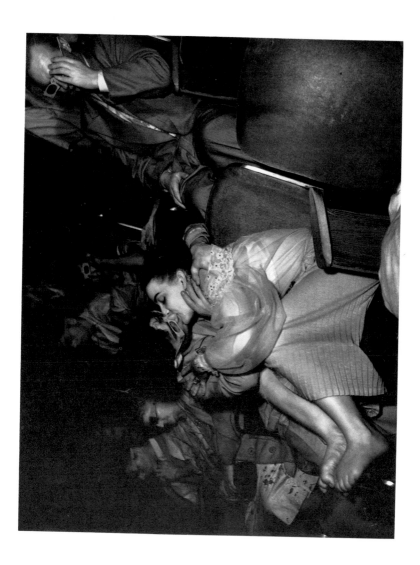

23. In the dressing room.

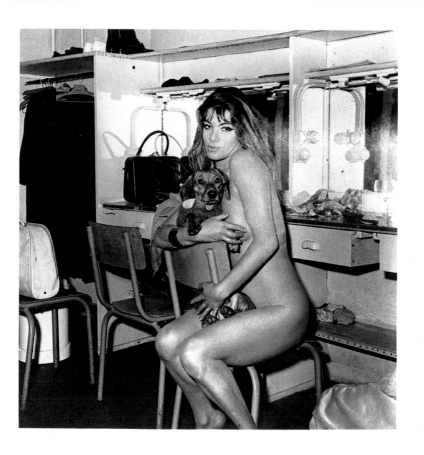

24. Gunsmith's sign

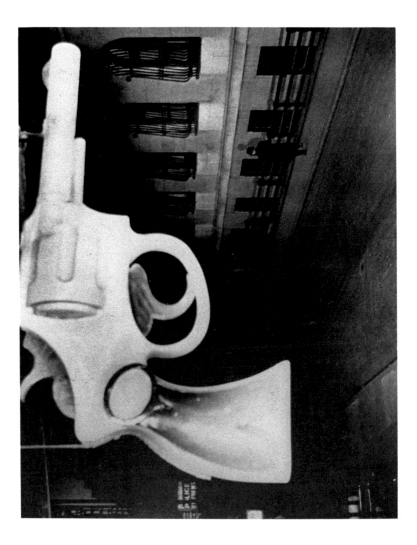

25. In the paddy wagon.

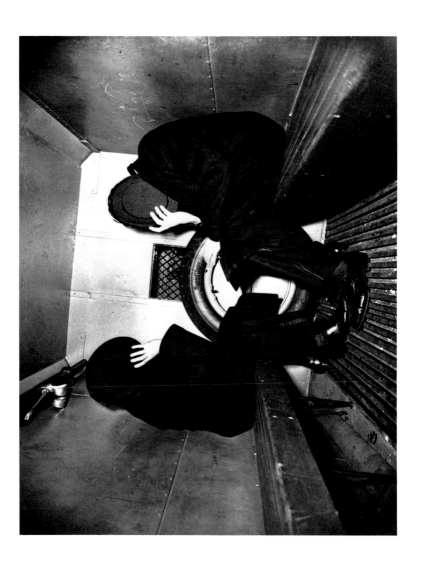

26. Ambulance, ca. 1943.

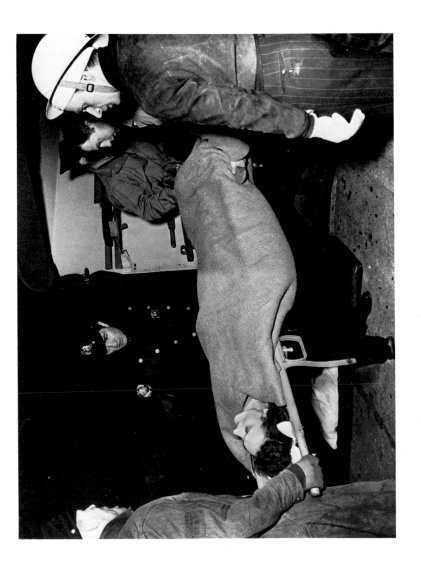

27. Transvestite in the paddy wagon, 1940.

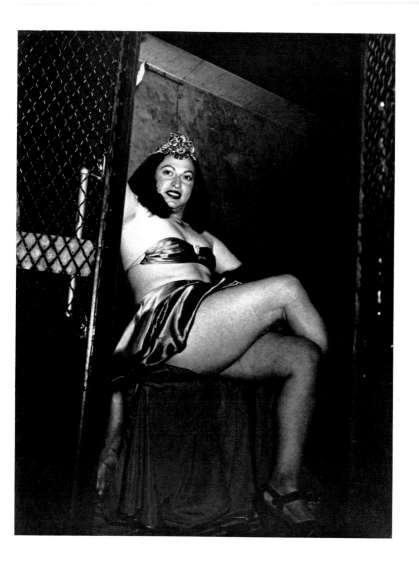

28. Shock, 1940.

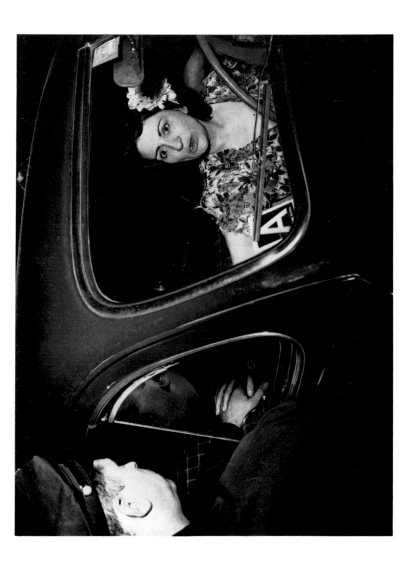

29. Car accident, ca. 1938.

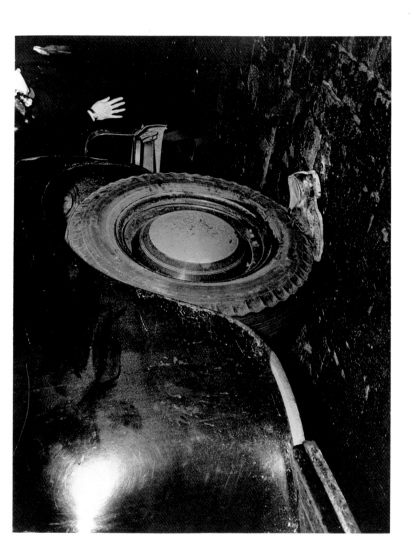

30. Dead man in a restaurant.

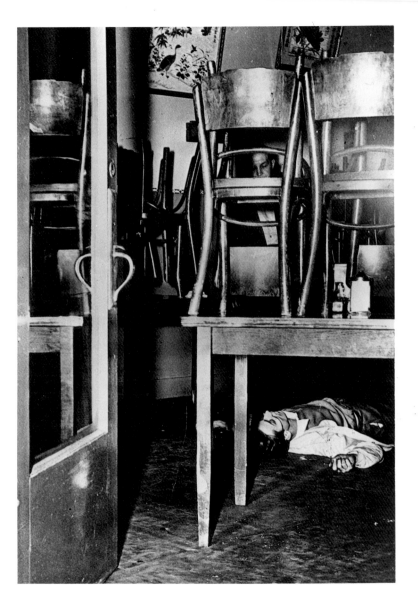

31. Cop killer, 1939.

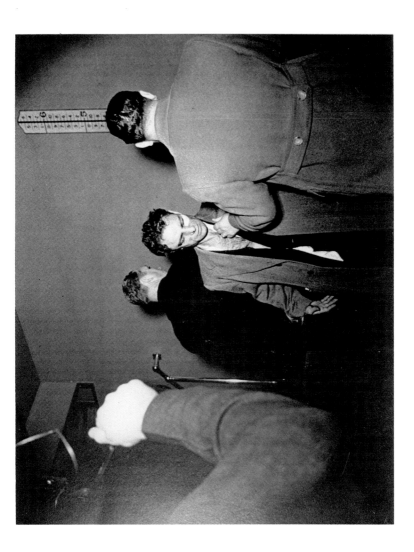

32. Killed in a car crash.

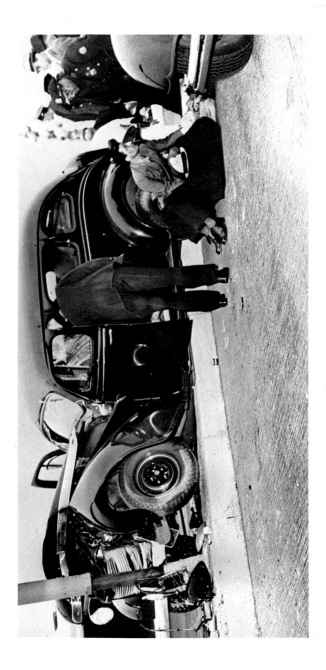

33. Tramp on Lower East side hit by a taxi.

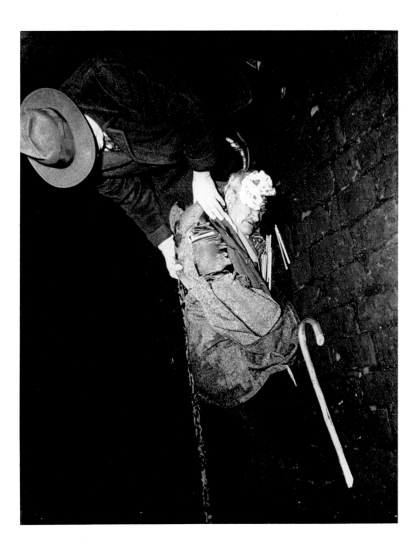

34. Alan Downs killed his wife.

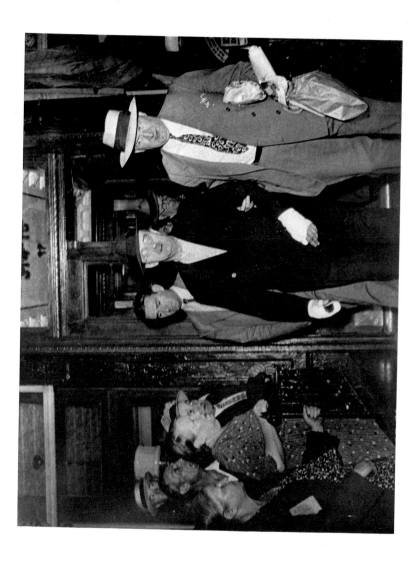

35. Corpse with revolver, ca. 1940.

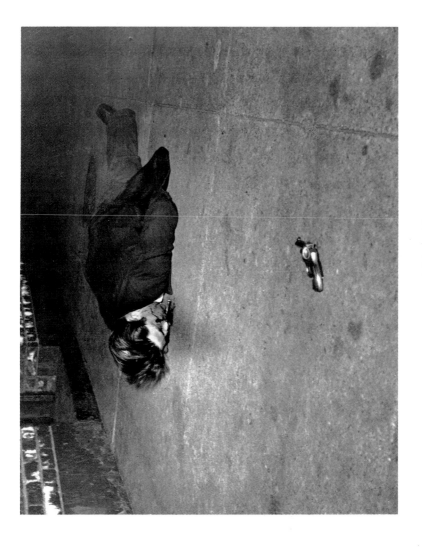

36. An injured tramp receiving the last Sacrament.

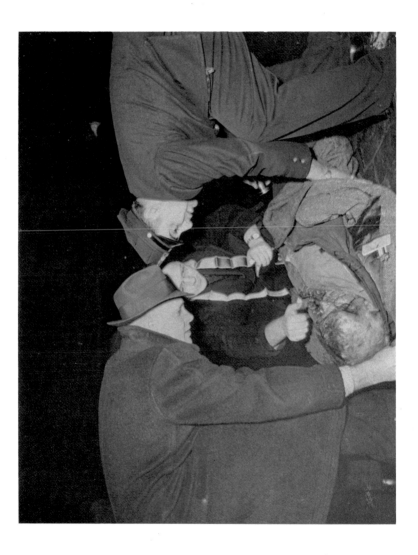

37. In the paddy wagon.

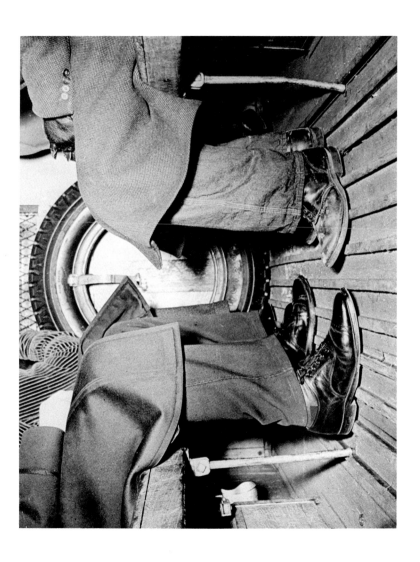

38. The end of a joyride.

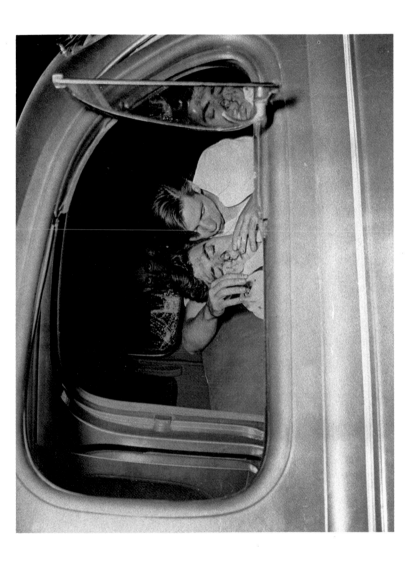

39. Transvestite, ca. 1940.

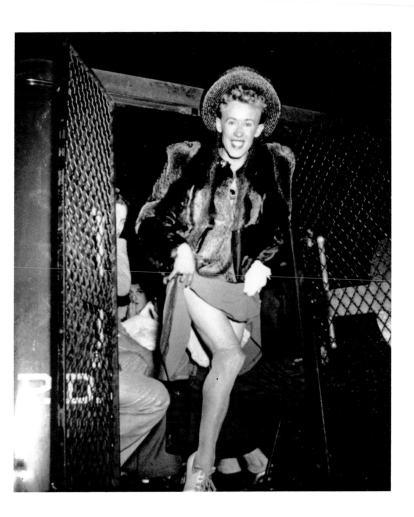

40. He killed someone, ca. 1940.

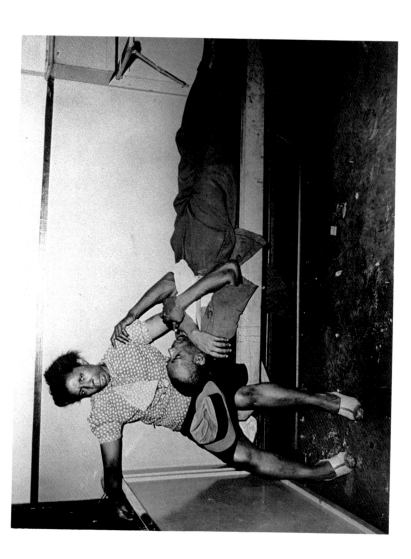

41. Accident or crime?

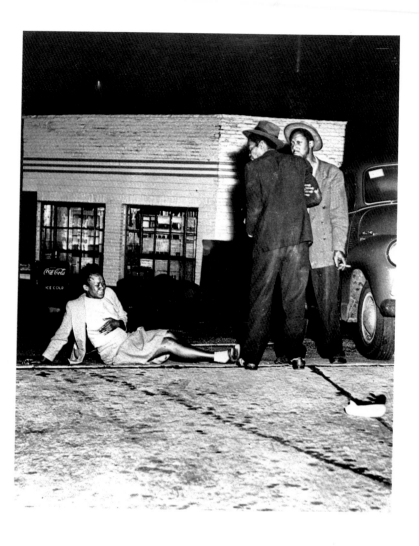

42. Untitled.

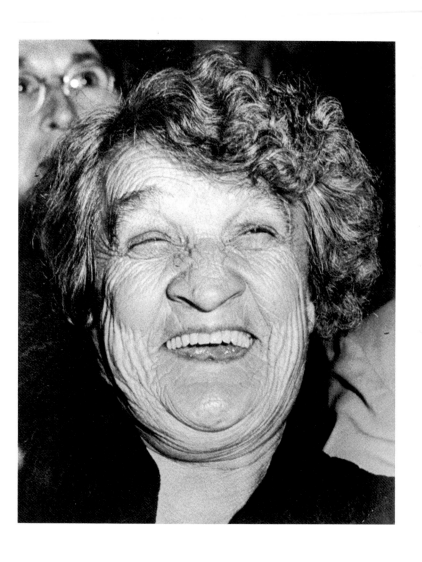

43. Waiting.

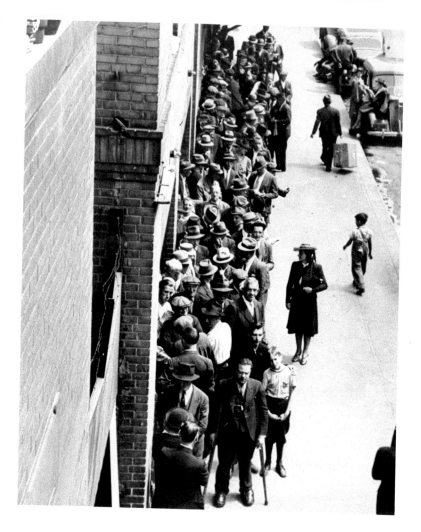

44. Summer on Lower East Side, 1947.

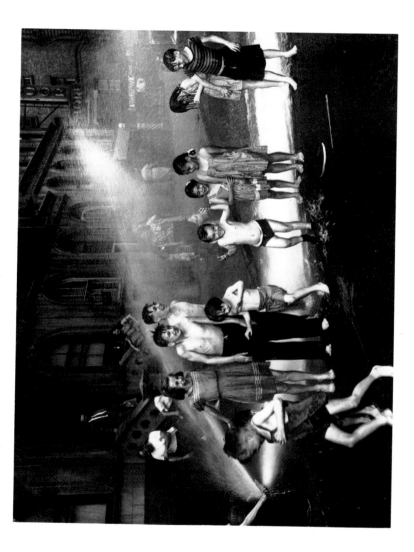

45. Children on the fire escape, 1938.

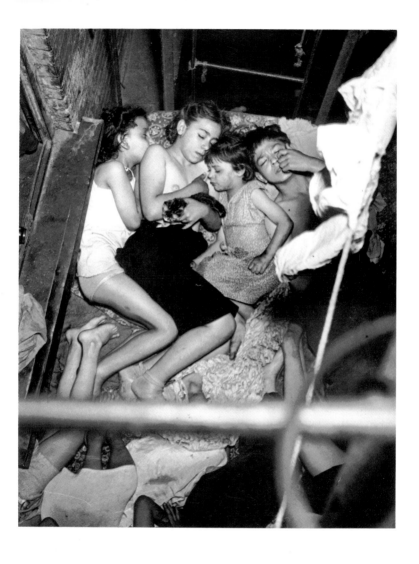

46. Flower seller, 1941.

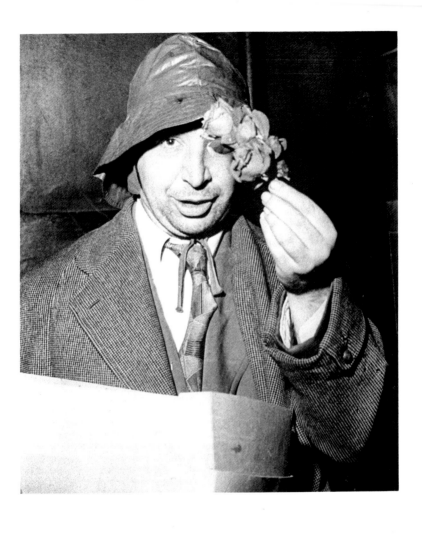

47. Night-club dancer.

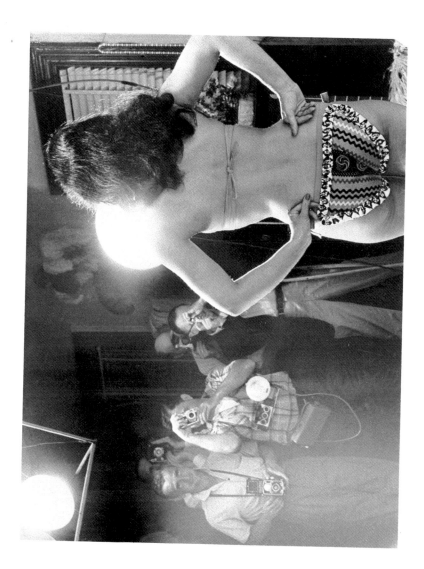

48. Distortion.

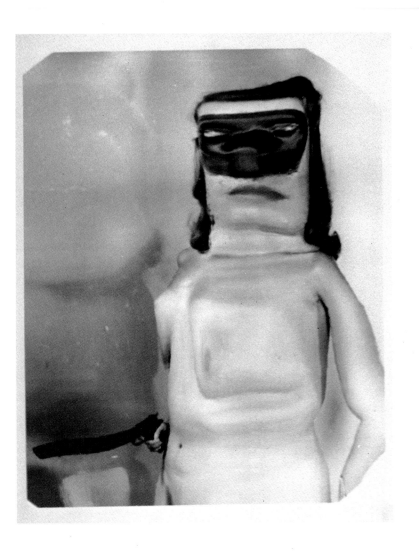

49. Weegee and model.

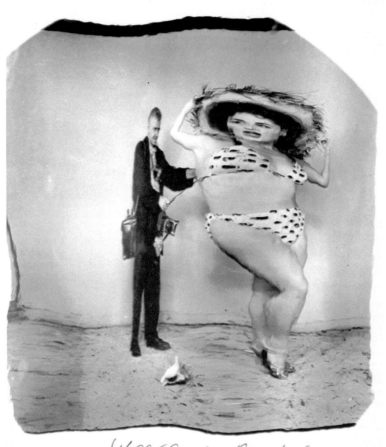

Weegee + model

50. Caricature of Richard Nixon.

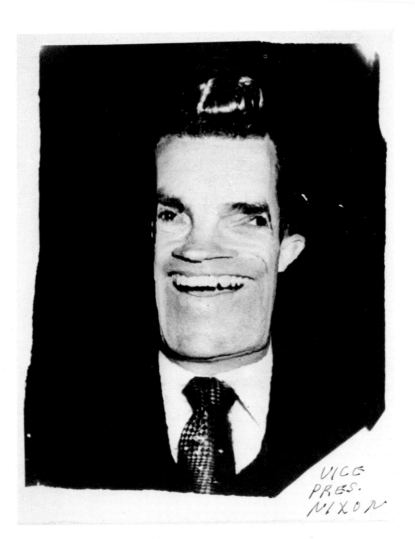

VICE
PRES.
NIXON

51. A stripper posing for the press photographers.

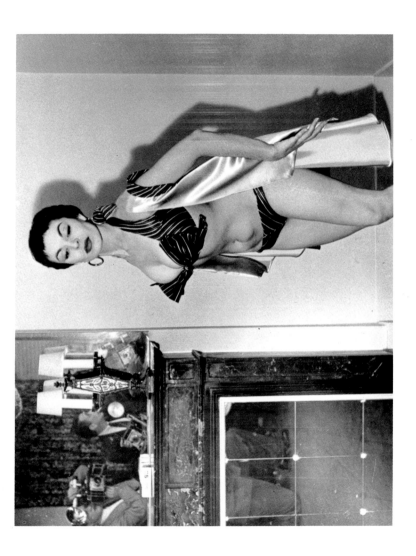

52. Audience.

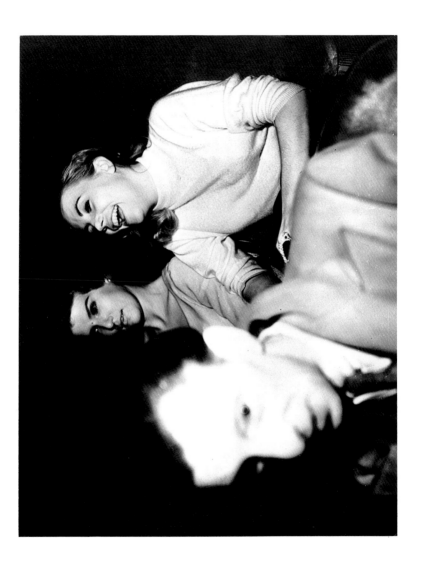

53. New Year's Eve at Sammy's in the Bowery, 1943.

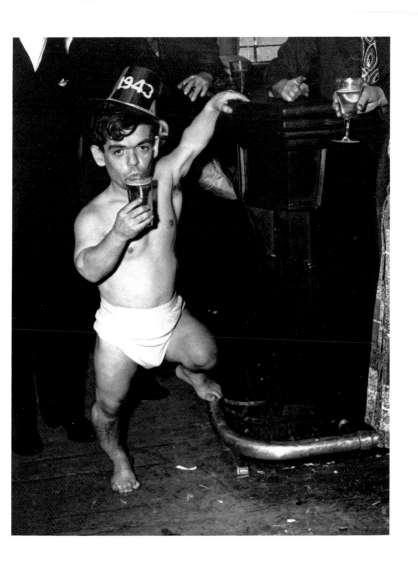

54. Norma at Sammy's in the Bowery, ca. 1945.

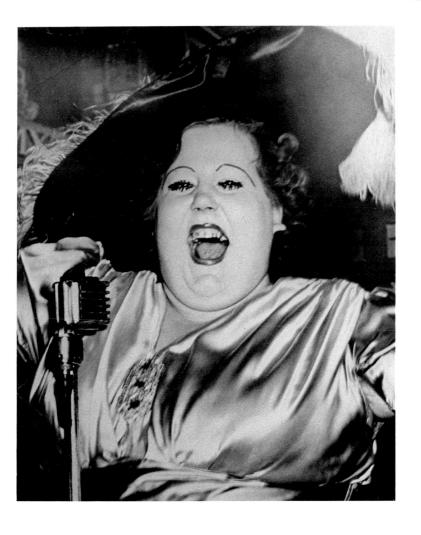

55. At Sammy's in the Bowery, ca. 1944.

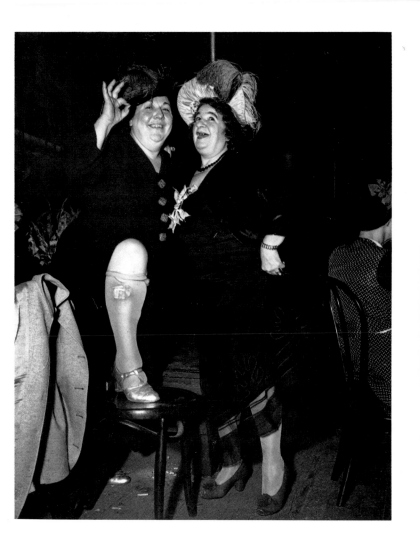

56. In a city bar.

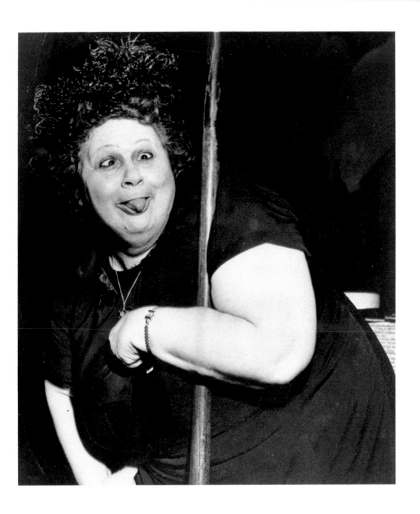

57. Singers rehearsing at the Met, 1943.

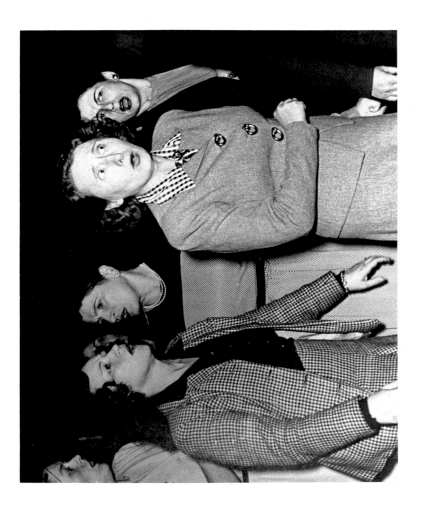

58. Singers rehearsing at the Met, 1943.

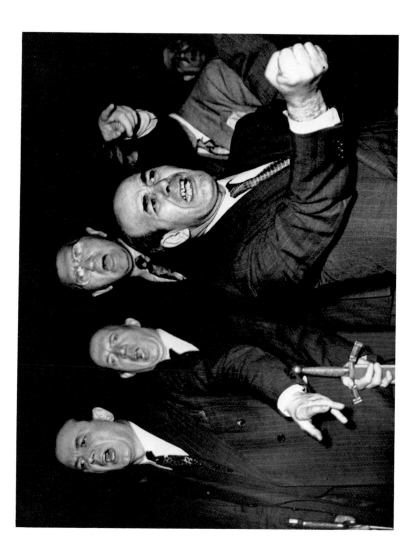

59. Dylan Thomas.

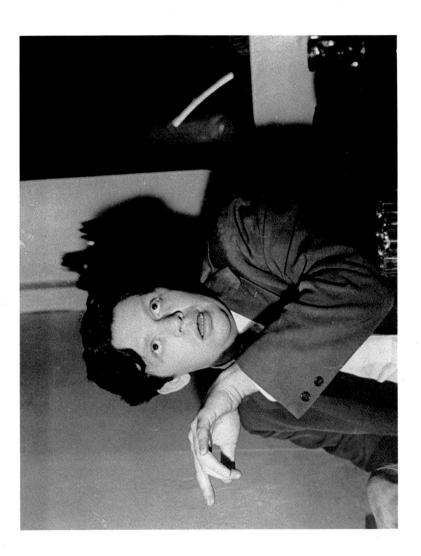

60. Shooting session.
61. Coney Island, July 28, 1940, 4 o'clock in the afternoon.

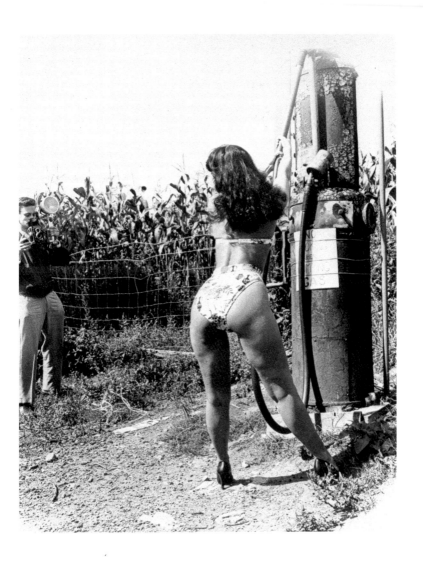

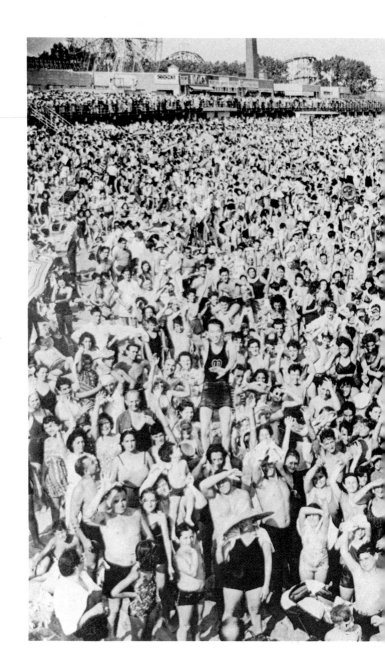

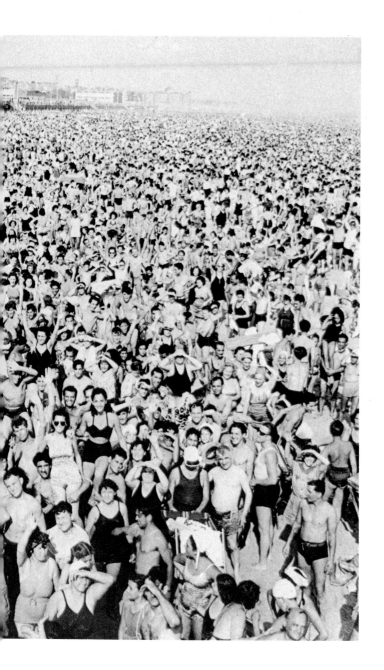

62. Marilyn Monroe.

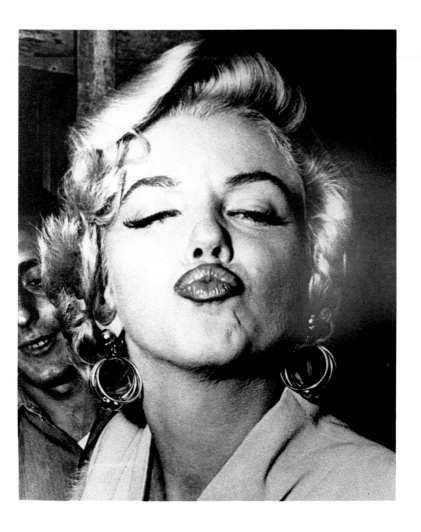

BIOGRAPHY

1899. Born on June 12 at Zloczew, an Austrian town that later became part of Poland. Given name: Usher (later changed to Arthur) Fellig.

1910. Family emigrates to the United States and settles on New York's Lower East Side. Father goes from job to job, subsequently becomes a rabbi.

1910-13. Attends public school.

1914-24. Works at different jobs: selling candy on the street, busboy, helper in a commercial photographer's studio, street tintype photographer, mainly of children.

1924-35. Plays violin at a silent-movie theater. Works in a passport photo studio for nearly three years.
Joins the Acme Newspictures agency as a darkroom assistant; is sent out unofficially on jobs in emergencies, usually at night.
Purchases his first camera, a Speed Graphic "4 x 5", with photoflash, in 1930.

1936. Begins career as news photographer. For the next ten years, works closely with the police out of Manhattan police headquarters, where news of accidents, crimes, and catastrophes is first reported; receives nickname "Weegee".

1938. First press photographer to obtain official permission to install a police radio in his car, allowing him to be first on the scene of any news event. During this period, becomes the most well known spot news photographer, photographing, according to some accounts, more than 5,000 stories, mostly concerning accidents, fires, and crimes committed at night, in an expressionistic style, often using a flash to accentuate shadows and lights. Works for the *Herald Tribune*, the *World Telegram*, the *Daily News*, the *Post*, the *Sun*, and for the press agencies Associated Press Photos, Acme Newspictures, and World Wide Photos. Also begins taking pictures that will be part of a satirical statement on New York society.

1940. Signs 4-year contract with PM magazine, with freedom to choose his subjects and submit photos shot with infrared film.

1943. One of his photos is included in the exhibition "Action Photography" at the Museum of Modern Art, New York.

1944. First personal exhibition.

1945. Publishes his first book, *Naked City*.

1947. Goes to Hollywood to work on film *Weegee's New York*, based on *Naked City*, produced by Mark Hellinger (Universal Pictures).

1948-52. Technician, adviser, and actor in Hollywood.

1953. Publishes *Naked Hollywood*.

1956. Marries Wilma Wilcox.
During the '50s, takes pictures of stars and politicians, playing up distortions and effects created with mirrors and kaleidoscopes.

1957. Creates a sequence for the film *Windjammer* using special lens effects.

1958. Adviser for special effects on Stanley Kubrick's film *Dr. Strangelove*. Returns to New York. Spends remaining years perfecting trick photography and photographic caricatures of political personalities. Travels to Europe; signs a contract with the *Daily Mirror*.

1968. Dies on December 26 in New York.

BIBLIOGRAPHY

Compiled by Stuart Alexander
(Each section in chronological order)

Books by Weegee

1945. Naked City, Preface by William McCleery. New York: Essential Books. 243 pages, 231 photographs. Facsimile by Da Capo Press, New York, 1975, 1985. Cincinnati: Zebra Picture Books. 86 photographs (smaller edition).

1946. Weegee's People, New York: Essential Books, Duell, Sloan and Pearce, 1946. 267 photographs. Facsimile by Da Capo Press, 1975, 1985.

1953. Naked Hollywood, New York: Pellegrini and Cudahy, 1953. 152 photographs. Facsimile by Da Capo Press, New York, 1976.

1953. Weegee's Secrets of Shooting with Photoflash, Compiled by Mel Harris. New York: Designers 3, Hartis Publishers. 64 pages, 40 photographs.

1959. Weegee's Creative Camera, Roy Ald, Garden City, New York: Hanover House. 128 pages, 165 photographs, 57 illustrations.

1961. Weegee by Weegee: An Autobiography, Introduction by Bruce Downes. New York: Ziff-Davis. 3 portraits, 62 photographs, 30 illustrations depicting Weegee with his camera, 6 illustrations; Da Capo Press, 1975, 1985.

1964. Weegee's Creative Photography, with Gerry Speck. London: Ward, Lock & Co. 1 Portrait, 64 photographs, 15 illustrations.

Books about Weegee

1977. Weegee, Published with an introduction by Louis Stettner. New York:

Alfred A. Knopf, 1977. 184 pages, 1 portrait, 114 photographs. Bibliography.

1978. Weegee, Introduction by Allene Talmey, Aperture History of Photography, Series no. 8. Millerton, New York: Aperture. Paris : Nouvel Observateur/Delpire. 95 pages, 42 photographs. Chronology, bibliography.

1978. Weegee: Täter und Opfer, Introduction by John Coplans. Munich: Shirmer/Mosel. Italian edition: **Weegee: Violenti e Violentati,** Milan, 85 photographs.

1982. Weegee's New York: 335 Photographien, 1935-1960, With an excerpt from **Weegee by Weegee.** Munich: Shirmer/Mosel.

1982. Le New York de Weegee: Photographies 1935-1960, With an excerpt from **Weegee by Weegee.** Paris: Denoël. 335 photographs.

1982. Weegee's New York: 335 photographs, 1935-1960, Introduction by John Coplans. Munich: Schirmer/Mosel. New York: Grove Press. 335 photographs. Bibliography.

1984. Weegee: Credit Photo by Weegee the Famous, Essay by Peter Martin. San Francisco: San Francisco Museum of Modern Art, 1984. 39 pages, 25 photographs, 2 portraits. Exhibition catalogue.

Periodicals

Photographs by Weegee were reproduced in New York newspapers beginning in 1936. These included **the Daily News, Herald Tribune, Journal American,**

Post, Sun, and World Telegram. His photographs were also published in numerous other periodicals in the United stated through Acme Newspictures, the Associated Press and World Wide Photos.

Articles

Reilly, Rosa, "Free-Lance Cameraman," Popular Photography, vol.1, no.8 December 1937 pp. 21-23, 76-79.

Meetze, Florence, "How 'Pop' Photo Crashes an Opening," Popular Photography, vol. 1, no.8, December 1937, pp. 36-38, 80-81.

Weegee, "Travel: A N.Y Police Reporter's Impressions of Washington", PM's Weekly, 2 march 1941, p. 50.

Steiner, Ralph, "Weegee Lives for His Work and Thinks Before Shooting", PM's Weekly, 9 march 1941, pp. 48-51.

Wilson, Earl, "Weegee", Saturday Evening Post, vol. 215, no.47, 22 May 1943, pp. 37-39.

"The Press: Weegee", Time, 23 July 1945, pp. 70-71. 5 photographs. Review of Naked City.

"In New York - Victory V's of Blazing Sawdust: VJ Day, New York - Photographed Especially for Vogue by Weegee", Vogue, vol. 106, no.4, 1 September 1945, pp. 116-117. 1 photograph.

"Weegee's People", Minicam Photography, vol. 10, no.6, march 1947, pp. 60-63. 4 photographs.

Wolbarst, John. "Weegee goes to 35 mm", Modern Photography, vol. 18, no.10, October 1954, pp. 100-101. 3 photographs.

"Speaking of Pictures... Artful tricks with a Camera Create Gallery of Satirical Partial Portraits", Life, vol. 37, no.22, 29 November 1954, pp. 10-11, 5 photographs.

Barry, Les, "Weegee Covers the Circus", Popular Photography, vol. 42, no.4 April 1958, pp. 126-127.

Stettner, Louis, "Uncouth Genius", Photography (London), vol. 15, no.12, December 1960, pp. 34-41.

Stettner, Louis et James M. Zanutto, "Focus on: Weegee", Popular Photography, vol. 48, no.4, April 1961, pp. 40-41, 101-102.

Fondiller, Harvey V. "Critics at Large: Weegee's Living Screen", Popular Photography, vol. 59, no.3, September 1966, p. 44.

Fondiller, Harvey V., Norman Rothschild, and David Vestal, "Weegee: A Lens on Life, 1899-1968", Popular Photography, vol. 64. no. 4, April 1969, pp. 92-95, 100.

"Weegee", Creative Camera, no.61, July 1969, pp. 252-259.

Stettner, Louis, "Speaking Out: Weegee: Naked City's Forgotten Man", Camera 35, vol. 15, no.7, September 1971, pp. 14-15.

Berg, Gretchen, "Naked Weegee", Photograph (New York), vol. 1, no.1, Summer 1976, pp. 1-4, 24, 26.

Westerbeck, Colin L., Jr., "Night Light: Brassaï and Weegee", Artforum, vol. 15, no.4, December 1976, pp. 34-45.

Coplans, John, "Photography: Weegee the Famous", Art in America, September-October 1977, pp. 37-41.

Thornton, Gene, "Photography View: The Satirical, Sentimental Weegee", New York Times, 18 September 1977, section 2, p. 29.

Lifson, Ben, "Photography: Weegee: Acquainted with the Night", Village Voice, vol. 22, no.43, 24 October 1977, P. 101.

Scully, Julia "Seeing Pictures: Weegee, the Famous, Turned News Photos into Powerful Social Documents. What Made Weegee Run?" Modern Photography, vol. 41, no.12, December 1977, pp. 8, 10, 24, 28.

Fondiller, Harvey V., "Gravure Portfolio: Weegee's New York", Popular Photography, vol. 82, no.6, June 1978, pp. 120-129.

"Weegee la combine", Photo (Paris), no. 133, October 1978, pp. 44-51, 102.

Badger, Gerry, "Viewed: Weegee, The Famous at Stills Gallery, Edinburgh", British Journal of Photography, vol. 126, no. 14, 6 April 1979, pp. 324-327.

Messadié, Gérard, "Weegee le Truculent", Photo Ciné Revue, May 1980, pp. 258-261.

Tytell, Mellyn, with John Tytell. "Encounters: The Houdini of Photography", Camera Arts, vol.1, no.3, May-June 1981. pp. 34-35, 105.

Lee, David, "Weegee in England", British Journal of Photography, vol.128, no.36, 4 September 1981, pp. 902-903, 914.

Martin, Murray, "Flash Suit, Flash Myth: An Interview with Weegee's Widow, Wilma Wilcox", Creative Camera, no.218, February 1983, pp. 834-837, 839, 841.

Coleman, AD, "Weegee As Printmaker: An Anomaly in the Marketplace", *Journal of American Photography*, vol. 3, no.1, March 1985, pp. 4-6.

Portfolios

Weegee: N.Y.C. 1939-1946, New York, Weegee Portfolios, Inc., 1982. Limited edition. 50 photographs.

EXHIBITIONS

Individual exhibitions

1944. "Weegee: Murder Is My Business," Photo League, New York.

1960. "Weegee: Caricature of the Great," Photokina, Cologne.

1962. "Weegee," Photokina, Cologne. "Photo Group Exhibition," Ligoa Duncan Art Center, Paris.

1975. "Weegee," Center for Creative Photography, Tucson, Arizona.

1976. "Weegee," Marcuse Pfeiffer Gallery, New York.

1977. "Weegee," International Center of Photography, New York.

1978. "Weegee," Galerie Zabriskie, Paris.

1979. "Weegee the Famous," Stills Gallery, Edimburgh.

1980. "Weegee," Daniel Wolf Gallery, New York.
"Weegee," The Photographer's Gallery, London.

1984. "Weegee," San Francisco Museum of Modern Art.
"Weegee," Boston University Art Gallery.

1985. "Two's Company," Light Gallery, New York.

Group Exhibitions

1943. "Action Photography," Museum of Modern Art, New York.

1948. "Fifty Photographs by Fifty Photographers," Museum of Modern Art, New York.

1962. "Photo Group Exhibition," Ligoa Duncan art Center, Paris.

1967. "Photography in the 20th Century," National Gallery of Canada, Ottawa.

1970. "Into the 70's: 16 Artists/ Photographers," Akron Art Institute, Ohio.

1974. "News Photography," Museum of Modern Art, New York.
"Photography in America," Whitney Museum, New York.

1977. "Documenta 6," Kassel. West Germany.

1978. "Tusen och En Bild, 1001 Pictures," Moderna Museet, Stockholm.

1979. "Photographie als Kunst 1879-1979," Tiroler Landesmuseum Ferdinandeum, Innsbruck.
"Amerika Fotografie 1920-1940," Kunsthaus, Zurich.

1980. "Southern California Photography 1900-1965," Los Angeles County Museum of Art.

FILMS

Films by Weegee

Weegee's New York, 1948, 16 mm, color, 20 min.

Cocktail Party, ca. 1950, 16 mm, black and white, 5 min.

Hollywood – Land of the Zombie.

San Francisco.

The Idiot Box, ca. 1965, 16 mm, black and white, 5 min.

Fun City, 16 mm, color and black and white, 75 min.

Films on Weegee

Weegee in Hollywood by Erven Jourden and Esther McCoy, ca. 1950, 16 mm, black and white, 10 min.

The Naked Eye by Louis Clyde Stoumen, Camera Eye Pictures, Inc., 1956, 16 min., color and black and white. 71 min.

PHOTOFILE

The Photofile series is conceived and produced
by the Centre National de la Photographie, Paris,
under the direction of Robert Delpire.